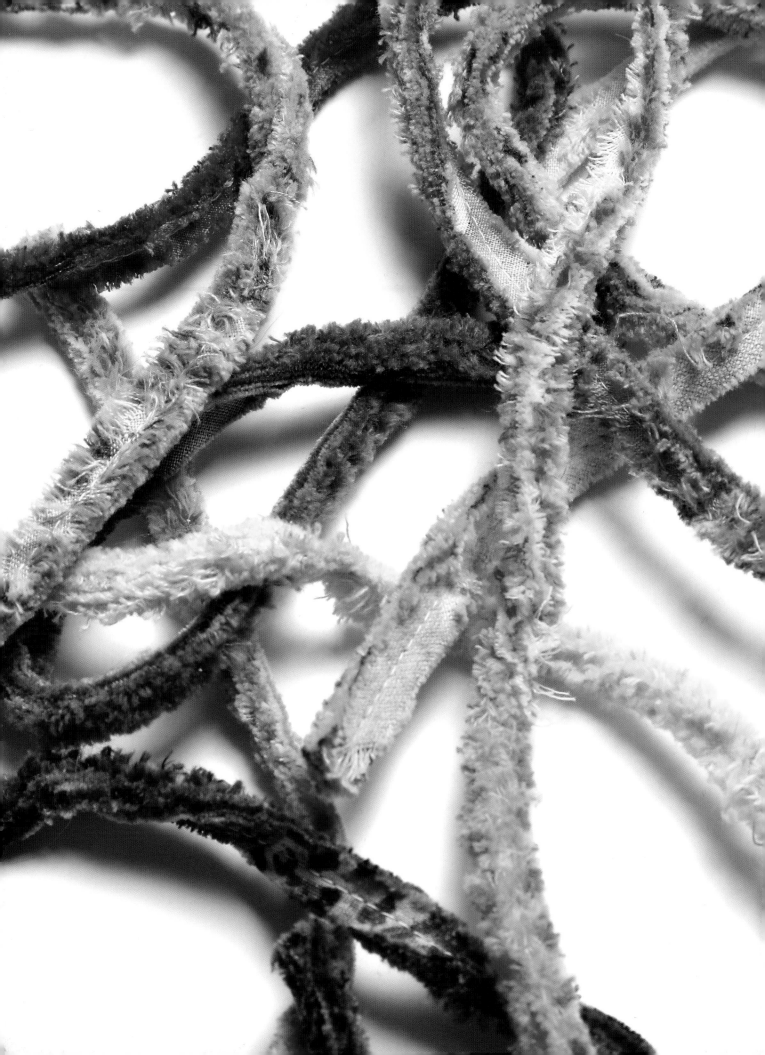

easy Chenille, APPLIQUÉ

Create Dimension the Color Stick Way

CHERYL MALKOWSKI

C&T PUBLISHING

Text © 2005 Cheryl Malkowski

Artwork © 2005 C&T Publishing, Inc.

Publisher: Amy Marson

Editorial Director: Gailen Runge

Acquisitions Editor: Jan Grigsby

Editor: Cyndy Lyle Rymer

Technical Editor: Joyce Engels Lytle, Sharon Page Ritchie

Copyeditor: Wordfirm

Proofreader: Wordfirm

Cover Designer: Kristy A. Konitzer

Design Director/Book Designer: Kristy A. Konitzer

Illustrator: Richard Sheppard

Production Assistant: Kerry Graham

Photography: Sharon Risedorph, Diane Pedersen, and Luke Mulks unless otherwise noted

Published by C&T Publishing, Inc., P.O. Box 1456, Lafayette, California, 94549

Front cover: *Shooting Stars* by Cheryl Malkowski

Back cover: *Decorated Tote* and *Pansy Toss* by Cheryl Malkowski

Library of Congress Cataloging-in-Publication Data

Malkowski, Cheryl.

Easy chenille appliqué : create dimension the color stick way / Cheryl Malkowski.

p. cm.

ISBN 1-57120-261-7 (paper trade)

1. Appliqué. 2. Machine quilting. 3. Chenille. 4. Fusible materials in sewing. 5. Decoration and ornament. I. Title.

TT779.M275 2005

746.44'5—dc22

2004010876

Printed in China

10 9 8 7 6 5 4 3 2 1

Appreciation

Being fully aware that I have not come to this place in my life alone, I would like to acknowledge those who have helped me see this dream become a reality. To start with, I would not be writing this book without the enthusiasm and integrity of Gillian DePaulo and Barbara Lewis, who took this technique and ran with it.

The editors and staff at C&T Publishing have been incredibly helpful. I appreciate Darra Williamson, who saw the potential of this idea and trusted me enough to give it a whirl. Jan Grigsby, my rescuer, helped me navigate through all sorts of unfamiliar territory, and Cyndy Rymer filled me in on the details. All the while, they treated me with more warmth and respect than I expected.

I owe my start in quilt teaching to Charlie Weckerle, who has been my constant cheerleader. She has helped me think outside the box, organize my thoughts, and focus my energy in positive directions. How can you thank someone enough who is willing to check your math?

My quilting companions and dearest friends—Jenny, Marie, and Patti—have dreamed with me, prayed with me, and supported me through every step of this journey. Their encouragement to "do it afraid" has kept me from turning back many times.

My students are a constant source of inspiration, and I'm especially grateful to the Gallery Girls who submitted projects.

I'd like to thank the YLI Corporation for helping me introduce this technique with samples of YLI's fabulous fusible thread, and I'd also like to thank Hobbs for the regular and fusible varieties of Heirloom Premium Cotton Blend Batting that are so perfect for this application.

Last but not least, I am grateful to my husband, Tom, who has always allowed me the freedom to develop my God-given gifts in a supportive environment; to my parents for raising me to believe I could do anything; and to Annie and Jeff for being proud of me even though their interests lie in very different arenas!

Table of Contents

Introduction

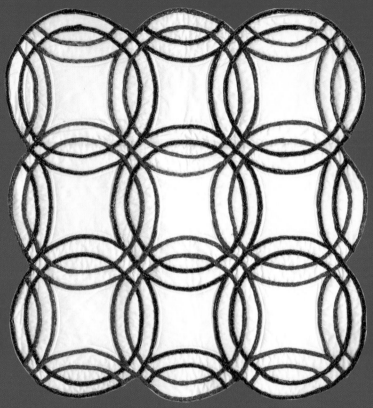

Chenille Wedding Ring, 38" × 38",
Gloria Beucler, 2003

We all remember the scenario—as a child at grandma's house, when we were allowed to curl up on her soft, wonderful bed with the beautifully patterned chenille bedspread. On that day, you felt really special! This book will bring you back to that place. With the help of your sewing machine and a few innovative tools and notions, you can create and draw with chenille. The chenille color stick technique is very simple. Start with three fabrics, stack them up, and cut them in half on the bias. Then stack those on top of each other and begin stitching along the bias edge with fusible thread in your bobbin. Yes, I said *fusible* thread!

Continue stitching in narrow rows all across your bias strip. When you're done, cut apart between the stitching lines. You now have a handful of color sticks! You're happy because you didn't have to handle these narrow little stacks of fabric individually; you cut them

after you sewed them together. These flexible sticks bend to any shape and, after pressing, adhere to any design you've drawn on your fabric. That's the beauty of fusible thread.

Once the design is fused to the quilt, it remains attached until you go back and stitch it in place during the machine quilting process. So be creative! No matter what you fuse, it will be there when you return to it!

Up to this point, your project may look unsatisfying: it's flat, it doesn't reveal its actual color, and every stitch shows. Hold on! This all just serves as motivation to keep you going. No unfinished projects for you! Once the whole design is sewn on and the quilting complete, the magic starts. Just put the whole thing in the washer and dryer. Poof! All the dimension and color you had hoped for magically appears. The quilt crinkles and puckers, masking less-than-perfect quilting, and the chenille color sticks grow into something lovely. Now you're back at grandma's, but right in your own home!

c h a p t e r

Choosing Fabrics and Batting

You'll use three different fabrics to make chenille color sticks. I like to use one solid, one yarn-dyed flannel or homespun plaid, and one print. The print gives you a great opportunity to raid your stash and use up fabrics that perhaps you wish you hadn't purchased or fabrics that you *know* you bought for a reason, although that reason escapes you now! You know the ones I mean—you wouldn't dare put them in a patchwork quilt because you know they will probably fade and spoil all your hard work. Maybe your taste in fabric has changed totally and you know you'll never use those fabrics for anything else. Now you can use them to make chenille color sticks!

COLORS: THE GOOD, THE BAD, AND THE UGLY

The most important thing to consider in choosing fabrics to use with the chenille color stick technique is color. Because the fabric is actually seen from the side in this application, it's important that both the front and back have colors you want seen in your color stick. Solids, woven plaids, or prints with good dye penetration work best.

You can tell whether a fabric has good dye penetration by turning it over and checking the back. A reverse side that is completely white or a color unrelated to the front will yield a less vivid color stick. If, on the other hand, the fabric is the same color on the back, or a color you wish to show in your color stick, it is be a great candidate for chenille color sticks. In general, the better the dye penetration, the more vivid the color of the chenille color stick. In lighter color sticks, dye penetration is not as great a factor as it is in darker color sticks.

Examples of bad dye penetration

Front and back of good fabric

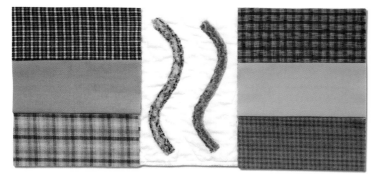

Color sticks made with plaid

Loosely woven plaids, such as homespuns, are great for chenille color sticks. When they are washed, they add little dots of different colors from the ends of the yarns.

Plaids with metallic threads running through them add a special glitter to your project.

Prints with good dye penetration will add sparks of different colors similar to the plaids but not as pronounced.

Tip: Try to avoid fabrics that are stiff because the lack of suppleness makes it hard for the fibers to separate and fluff.

Whatever your fabric choices, you will find that your color stick is more interesting with some variation in the colors used. Don't be afraid to mix colors you wouldn't think of mixing in patchwork, because they all blend in the color stick. Most of the time, a little variation creates excitement.

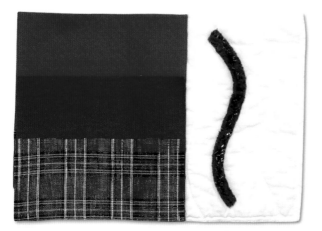

Color stick made with metallic plaid

TEXTURE: FLANNELS AND HOMESPUN PLAIDS

Solid flannels add a velvety feel to the color sticks and make very soft chenille. Homespun plaids add color bits and fluff well because they are loosely woven. Either type of fabric is an excellent choice for the top of your stack when you make your color sticks.

Tip: Using all flannels is fun, but if they are thick, quilting-quality flannels, choose two and make only four layers. Otherwise, the color sticks will be very thick and you'll break needles during the stitching process.

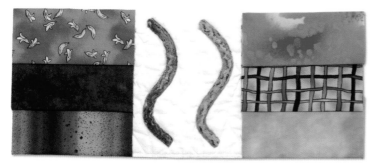

Color sticks made with good prints

BACKGROUND FABRIC AND BATTING

When choosing background fabrics, keep in mind that a lightweight solid, a tone-on-tone, or a lightly printed fabric will give you the best results. If your background is too busy, your chenille design will be lost.

The exception to this guideline is when you use chenille to enhance a preprinted motif on a fabric—a fun and easy way to personalize a project.

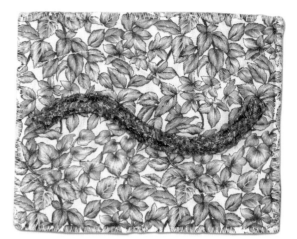

Color stick on a busy background

Batting selection is important; you need a batting that will shrink to achieve the puckered look in the quilting and to push the color stick fibers together for great chenille. I prefer Hobbs Heirloom Premium Cotton 80/20 batting because it is lightweight, puckers nicely, and has a wonderful hand after washing. For small projects, I find that if I press the quilt from the front and the back with a steam iron, it will cling together without pinning, which is a big time-saver. For larger projects, a fusible batting eliminates the need to pin. Any machine-washable cotton batting that shrinks will work fine, but 100% polyester batting doesn't work well because it doesn't shrink. The resulting chenille is not as full and fluffy on polyester batting, and you have to spend time brushing it to get the look you're after.

Tip: Remember, for the best chenille and a crinkled look, *do not prewash* background fabric or batting!

Chenille around printed motif

Chenille Color Stick Appliqué

TOOLS, EQUIPMENT, AND NOTIONS

Making chenille color sticks is easy and requires only a few simple tools. You need your sewing machine, a 6″ × 24″ ruler with a 45° angle marking, scissors or rotary cutter, quilt-marking tools, a stiletto or glass-head pins, a steam iron, and possibly a stiff nylon-bristle brush. You use fusible thread in your bobbin to make the color sticks. This makes them stay in place during the design and quilting phase.

Tip: You may need to ask your local quilt shop to order fusible thread. YLI makes my favorite. See Resources on page 47 for fusible thread manufacturers.

Use a gray or neutral thread for the top thread as you sew the bias strips. To sew the chenille color sticks in place and quilt the entire project, you also need cotton thread that matches your background fabric.

STACKING AND STITCHING

The number of chenille color sticks you need and the most convenient length for your particular project determine how you cut out the bias strips. You begin by stacking three fabrics with right sides up. The placement of the fabrics doesn't matter nearly as much as you think it might. All the colors will show and the top fabric doesn't always show the most. Usually the one that shows the most is the fabric that frays the best—often the flannel or the homespun plaid. So jump in and pick one—it will be okay!

Tip: For instant success on your first project, use a flannel or homespun for the top layer. Begin experimenting on later projects.

For every pattern presented in this book, the dimensions given are for the rectangle of fabric from which you will make the color sticks.

1. Stack the three fabrics and mark the exact horizontal and vertical center. For example, if you are using ¼-yard lengths of 44″ or 45″ fabric, start by laying them on top of each other, right sides up. Trim them all to the width of the narrowest fabric. Let's say you have three 9″ × 40″ layers after the selvages are trimmed. Measure 20″ from the selvage and 4½″ from the top to find the center and mark it. Put a pen point on the center dot; align your ruler along the bottom edge of the fabric, using the 45° line on the ruler as a guide. Leave the ruler there, and use the rotary cutter to make two pieces the same size.

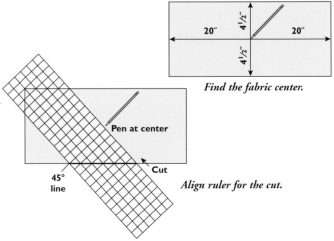

Find the fabric center.

Align ruler for the cut.

Turn one of the pieces and place it on top of the other so you have six layers.

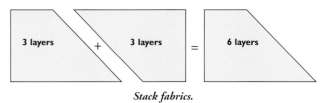

Stack fabrics.

2. Set your stitch length to 8 stitches per inch. Use gray thread in the top of your machine and fusible thread in your bobbin. The gray thread helps distinguish the top of the color stick from the bottom so you can avoid fusing the color sticks to your iron!

3. With the regular presser foot on your machine and the needle in the center position, you should be able to use the edge of your presser foot as a guide to stitch back and forth across the fabric. Start stitching along the bias edge, about ³⁄₁₆″ from the raw edge.

> **Tip:** Be careful to sew along the *bias* edge, or your color sticks will shred instead of fluff!

4. Continue stitching across the bias strip about ³⁄₈″ apart. Lift the presser foot and pivot at the end of each stitching line without cutting the thread. As long as the stitching doesn't get any closer together than ¼″, it doesn't have to be straight or perfect—it all seems to come out in the wash!

> **Tip:** Don't worry if your bias strips distort badly at this point. They will look great after they're cut apart!

> **Tip:** When a wider chenille color stick is desired, just stitch ½″ apart and cut down the middle. It won't be possible to stitch in both directions, but it still doesn't take long.

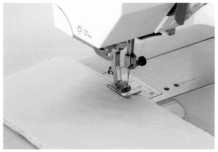

Begin stitching.

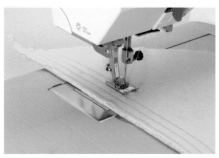

Continue stitching.

CUTTING INTO STICKS

After sewing across all of the bias strip, you're ready to cut apart the color sticks between the lines of stitching. Use a rotary cutter or scissors. The color sticks don't have to be perfectly straight; there are ways to handle some that you think are unusable. As long as they are at least ¼″ wide and have a row of stitching, they will work.

> **Tip:** I don't recommend using your ruler with the rotary cutter in this process unless your stitching is ruler-straight, or you'll end up with your cuts off-center. A really lopsided color stick poses certain problems, which we'll discuss a little later.

Cut the ends of all the color sticks straight across. This will keep every exposed edge of the color stick on the bias so it won't unravel.

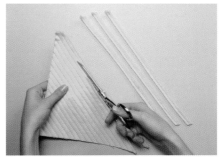

Cut color sticks.

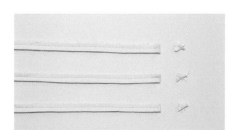

Blunt cutting the color sticks

MARKING YOUR PROJECT

Quilts are usually marked before the quilt sandwich is layered. Make a full-size template from the chenille color stick design pattern for your project. Decide which marking tool will work best for you depending on your fabric.

Light-Colored Fabrics

A water-soluble pen works well on light-colored fabrics. Trace the design with the fabric on top of the template. Use a lightbox if necessary to help you see the design.

Dark or Thick Fabrics

Use dressmaker's carbon on top of the fabric and a serrated tracing wheel. Place the template on the top of the carbon and trace over it with the wheel. This method adds marks that do not last as long as those made with the water-soluble marker; work from one side of the design to the other when tracing. Avoid repeatedly pressing on the design because the pressure will erase it. Consider retracing the design with a white pencil.

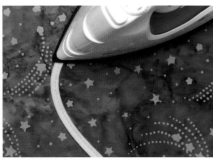

Begin to press.

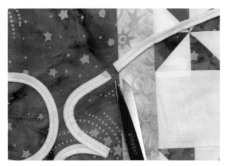

Blunt cut while pressing.

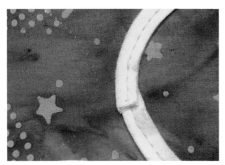

Overlap color sticks.

PRESSING THE COLOR STICKS

If your project is a quilt, pin baste the layers together now. Press all layers thoroughly, starting in the center and working outward on both the front and the back using a hot steam iron, adjusting or removing pins as needed. The next step is to press the color sticks, fusible side down, onto the design. The fusible thread will cause the sticks to stay in place, and this extra pressing will cause the quilt layers to cling tightly together so quilting will be easier.

1. Use a hot iron with lots of steam to force the heat through all those layers to melt the thread. Test the fabric to see how hot you can set the iron without scorching the fabric. Again, steam is vital!

2. Set the color stick on the design line, fusible side down. Press small sections at a time, going all around the design and checking the fusing as you go. Every time you cut a stick to fit the design, blunt cut it so a bias edge will be exposed.

3. When you've pressed your whole color stick and still have more design to cover, continue with a new color stick, placing the new one on top so it overlaps the old one by about ¼". When these are aligned well they usually don't show once the project is washed. If they do, you can trim them a bit and they'll blend right back into the design.

Corners

When you approach a corner, there are two ways to handle it, depending on how sharp you want the corner to appear. One method is to blunt cut the color stick at the corner point and lay the next one right on top but going in the other direction.

> **Tip:** Be sure to lay the color sticks down with the fusible thread facing the project or you will have cute little color stick designs on your iron!

The second method is to press the design securely to the corner and insert a stiletto or glass-head pin at the corner. Then pull the color stick in the new direction and continue to press. These corners will not be as pointed as corners made using the first method, but at times you will want to use this technique.

Curves

When pressing color sticks onto a curve, start by securing a small section, then curve and press as you go around the design.

Pressing a curved color stick

Circles and Spirals

Some designs call for little circles. These circles are easiest to create by first cutting the color stick to the appropriate length and then wrapping it around your finger, with the fusible thread on the inside. Manipulate it so it's flat and lay the color stick (fusible side down) on the fabric. Hold it in place with the side of the stiletto while you begin pressing. This also works for making the beginnings of spirals, which I always start in the center.

Dots

To make little dots, cut the color stick into squares and press in place. Because they won't have much fusible thread to hold them in place, dots should be the first things sewn down. Tack them in the center. Slightly overlapping dots make great flower centers, and dots cut from $\frac{1}{2}$" to $\frac{5}{8}$"-wide color sticks work well for small flower petals, as in the Toddler's Skort on page 43.

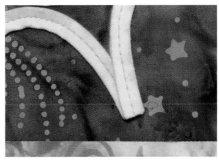

Sharp point technique

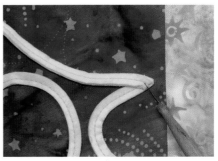

Round point technique

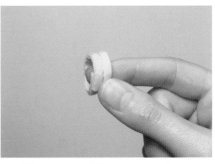

Wrap a color stick around your finger.

Use the stiletto on the side for circles or spirals.

Making dots

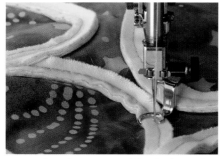

Stitching down center of fused color stick

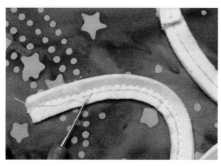

Removing off-center initial stitching

MACHINE QUILT THE STICKS

When all the chenille color sticks are fused to the project, use quilting thread and a darning foot or quilting foot, with the feed dogs down, to stitch them down. This actually begins the machine quilting process if your project is a quilt. Your goal is to stitch directly down the center of the color stick so both sides of the fluff will be the same. Most of the time you will be able to stitch along your initial stitching line. If the initial stitching does not run down the center of the stick, ignore it and stitch down the center of the stick. Once the stitching is complete, the off-center initial stitching can be removed easily using your stiletto or the end of a small pair of scissors because the bobbin thread has melted anyway!

Free-Motion Quilting

For most projects, free-motion quilting is the simplest way to attach the color sticks. Always bring your bobbin thread up to the top at the beginning of any quilting, and begin with about ½″ of really short stitches or backstitch at the beginning of the stitching. Because starting and stopping is time-consuming, it's good to look for ways to continue stitching. For example, if you're applying flower petals and there is room inside the flower for quilting, do both the quilting and flower petals while the needle is inside the flower. If possible, stitch from the end of one color stick to the beginning of another without stopping, hiding the stitching alongside a color stick if necessary.

There are times you will need to use a regular presser foot. When you apply color sticks in a straight line, or on or near the outside edge of a quilt in a pattern that follows that outside edge, using a regular presser foot helps keep the stitches even and straight.

After the whole design is stitched down, continue machine quilting until the whole project is quilted. Quilting between ½″ and 1″ apart in an allover pattern adds to the quaint, old-fashioned feeling after the project is washed.

If your project is a garment, bag, or other nonquilted item, just stitch the color sticks onto one layer of fabric and you'll be done!

Quilt Before Adding the Sticks

You can quilt a project *before* adding the chenille color sticks. This is a good option if you are not comfortable with free-motion quilting, or if you are sending your quilt out to be quilted by a longarm quilter. Be sure to mark the chenille design on the quilt ahead of time in a way that will still be visible when it is completely quilted.

THE MAGIC: YOUR WASHING MACHINE

Once the project is stitched down and completely quilted, it's time to wash it. If your project is a quilt with a binding, you need to finish the binding completely before washing. These projects can be put into the wash with regular laundry (no bleach) and dried in the dryer. As long as you've sewn and cut all your color sticks on the bias, you won't have a mess in your machines.

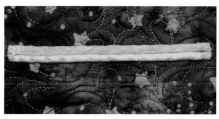

Chenille that needs brushing

> **Tip:** Because these fabrics are not prewashed, it is extremely important to put some sort of dye catcher—Retayne or some other dye-magnet product—in the washer to prevent colors from bleeding.

After your project is washed, but before it's dried, you'll be able to tell if it is fluffing as much as you'd like. If you can still see the stitching line on the color sticks, scrub with a stiff nylon brush to encourage the color sticks to fluff while the project is still wet. This is when you see the difference between the kinds of fabrics you've chosen as your top layer. Any fabric can be brushed into fluff, but some won't need any coercion at all.

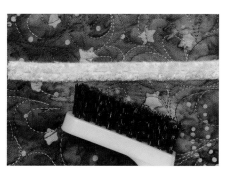

Brushed chenille

> **Tip:** Resist the temptation to brush all the chenille before your project is washed, unless you're trying to build upper body strength!

When you're satisfied with the fluff, put the project in the dryer. When it's dry, you're done!

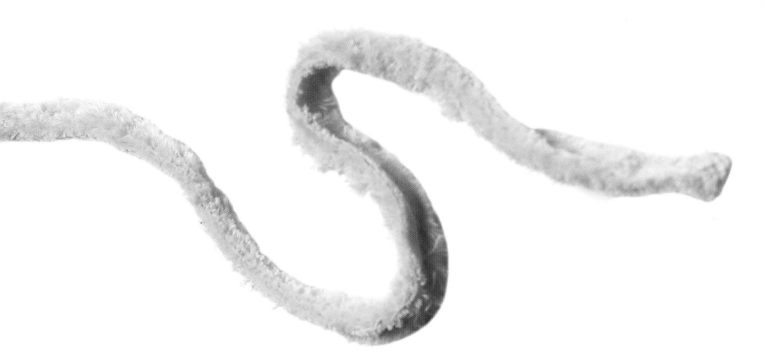

3

Celtic Weave Pillow

Cheryl Malkowski, 2003
Finished Size: 16″ × 16″

This project does not require free-motion stitching, so it is a good candidate for your first use of chenille color sticks. You may question why you need to use fusible thread in your bobbin since these lines will be easy to stitch down. Using fusible thread allows you to easily remove any irregular initial stitching by pulling it out with your stiletto. Without the fusible thread, the technique would not be nearly as forgiving.

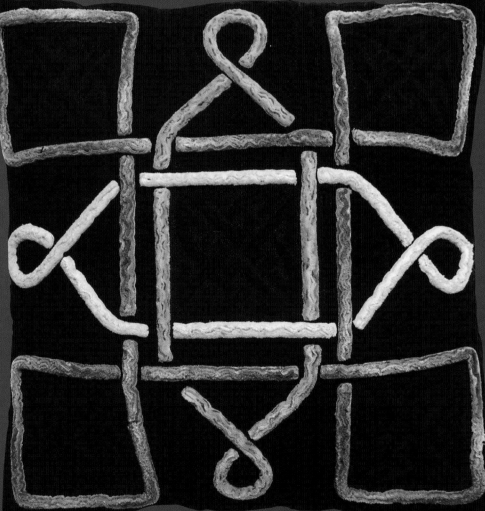

Cutting

Black: Cut 2 squares 18″ × 18″ for front and backing.

Cut 2 rectangles 14″ × 17″ for sham pillow back.

Construction

1. Fold one 18″ × 18″ square into quarters; press the folds to make a strong crease. Use the folds to center your design.

2. Using the Celtic Weave pattern on page 18, transfer the design for the chenille color sticks to the pillow front with dressmaker's carbon and a serrated tracing wheel. Match the center of the pattern design to the creased center of the pillow front. Rotate the pattern to mark each quadrant.

3. Layer backing, batting, and pillow front. Follow the directions on pages 10–15 for making and applying chenille color sticks. Quilt the whole pillow top.

4. Trim and square the outside edges, keeping the design centered so the remaining pillow top is 17″ × 17″.

5. Make a narrow hem for the pillow back by folding over ½″ along one 17″ edge of both 14″ × 17″ pieces. Press and fold it over again. Stitch close to the fold.

6. Match 3 raw edges of both pieces with the pillow top, right sides together, so the back pieces overlap in the center. Stitch around the outside edge using a ½″ seam allowance.

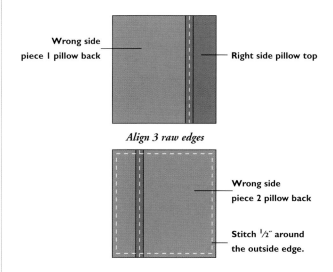

Wrong side piece 1 pillow back

Right side pillow top

Align 3 raw edges

Wrong side piece 2 pillow back

Stitch ½″ around the outside edge.

7. Turn right side out. Wash and dry to bring out the chenille and stuff it with the pillow form. Enjoy!

Materials

- Black: 1⅛ yards for front, backing, and sham pillow closure
- Batting: 18″ × 18″
- 16″ × 16″ pillow form
- Fusible thread
- Dressmaker's carbon and serrated tracing wheel

Chenille Color Stick Fabrics

- Teals: 3 different 9″ × 10″ rectangles
- Yellows: 3 different 7″ squares
- Greens: 3 different 7″ squares

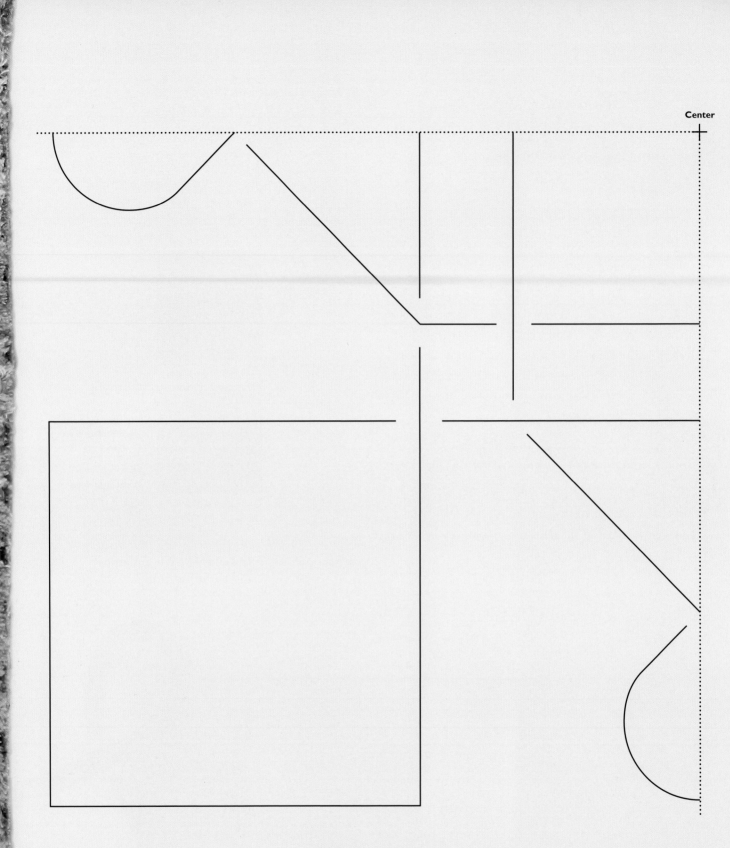

Celtic Weave quarter pattern

Salsa Bag

Red bag by Cheryl Malkowski; black bag by Ruby Kosola, 2003

Finished Bag Size: 15½″ × 13″ × 4″

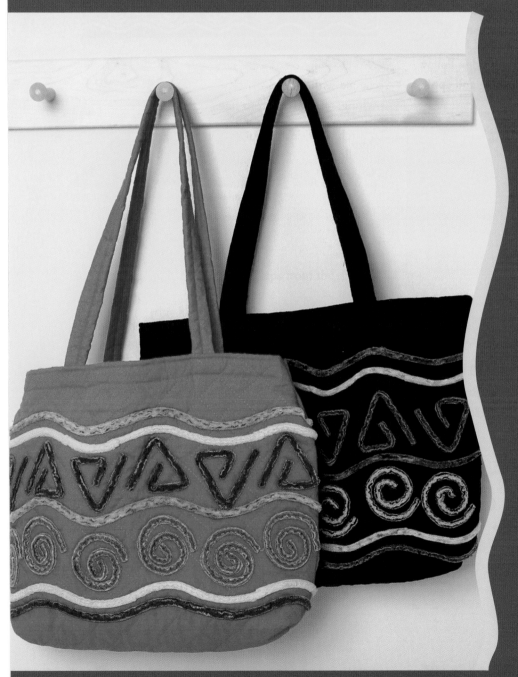

Here's a simple tote bag easily decorated with chenille color sticks. This is the perfect solution when you need a fast and easy gift! Or use this bag for your quilt projects, books, beach gear, groceries—you name it!

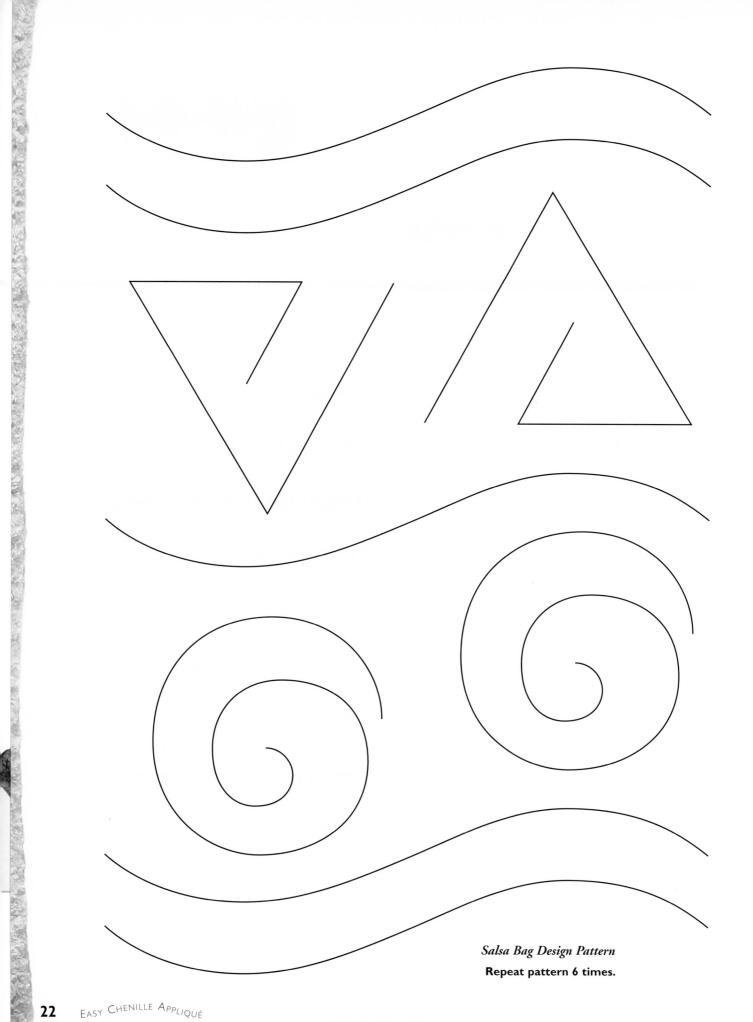

Salsa Bag Design Pattern
Repeat pattern 6 times.

Pansy Toss

Cheryl Malkowski, 2003

Finished Quilt Size: 54″ × 65″

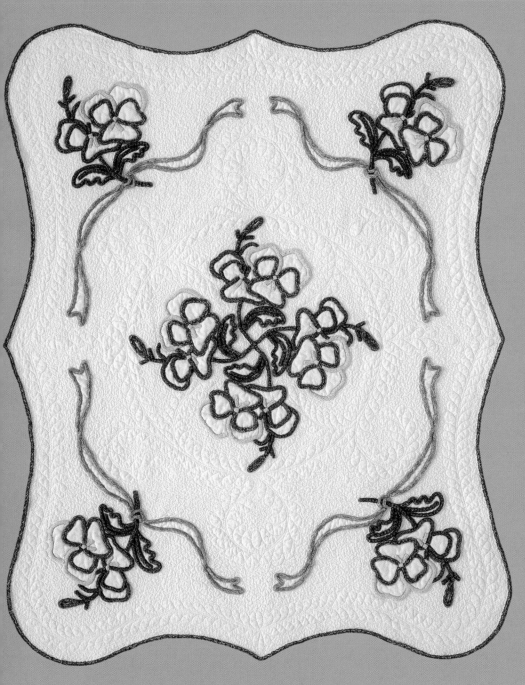

This wholecloth quilt borrows its charm from the chenille bed-spreads I grew up with. The combination of fuzzy chenille pansies and intense quilting makes it doubly nostalgic. Since its shape is decidedly not square, all three layers are sewn together and turned like a pillowcase, then edged with chenille color sticks. This makes the quilt construction and edge finish very simple. Another option for this quilt is to use the whole pattern as a template for a medallion in a rectangular quilt, which could then easily be used for a bedspread.

Construction

1. Cut the muslin in half lengthwise to make 2 pieces 60″ × 76½″. Set aside 1 piece for backing.

2. Fold the second piece into quarters, side to side, top to bottom. Press firmly to make creases at the folds.

3. Make the pattern for the outside of the quilt using the Pansy Toss Edge pattern on the pullout. Position the pattern on the folded fabric, matching the fold lines. Cut along the pattern line through all thicknesses, and mark crease placement dots on the top layer of the fabric.

4. Keeping the fabric folded, press all layers along the crease line from the crease placement dot to the center fold of the fabric. Be careful not to stretch the bias fold.

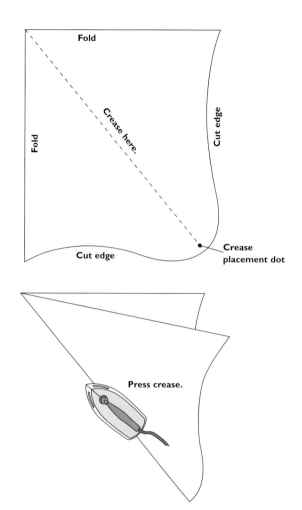

Folding the quilt top

Materials

- 120″-wide muslin: 2⅛ yards for front and back
- Batting: 60″ × 76½″
- Fusible thread
- Water-soluble marker

Chenille Color Stick Fabrics

- Blues: 3 different ⅜-yard pieces for flowers and outer edge
- Yellows: 3 different 9″ × 15″ rectangles for flowers
- Lavenders: 3 different 9″ × 24″ rectangles for flowers
- Greens: 3 different 9″ × 28″ rectangles for leaves and stems
- Peaches: 3 different 9″ × 27″ rectangles for ribbons

5. Using a water-soluble marker, transfer the placement dots and the chenille flower and ribbon patterns to the quilt top as follows:

Use Pansy pattern (see pullout, side 1) with 1 leaf for the center medallion. Match Dot 1 to the center and place Dot 2 along the horizontal and vertical fold lines. Adjust the stem lengths so they all meet in the center.

Use Pansy pattern with 2 leaves for the outside design. Place Dot 2 on the diagonal crease 6″ from the outside edge along the diagonal crease and Dot 1 on the diagonal crease toward the center.

Use Ribbon C pattern (see pullout, side 2) for the upper-left and lower-right corners, and Ribbon D pattern for the upper-right and lower-left corners. Rotate the ribbon so the "knot" fits correctly on the stem. Refer to the quilt photo for ribbon placement. This is your quilt top!

6. Layer the batting, then backing, with right side up; add the top with the wrong side up. Pin and stitch around the outside edge, using a ⅜″ seam allowance. Leave about 6″ open for turning. Trim the seam allowance at points just to stitching.

7. Turn the quilt right side out and press from both sides. Stitch the opening closed, keeping the curve intact.

8. Follow the directions on pages 10–15 for making and applying chenille color sticks and dots at flower centers.

9. Quilt, then wash and dry to bring out the chenille!

chapter

Shooting Stars

Cheryl Malkowski, 2003
Finished Quilt Size: 48½″ × 48½″

Finished Windmill and
Alternate Block Size: 9″

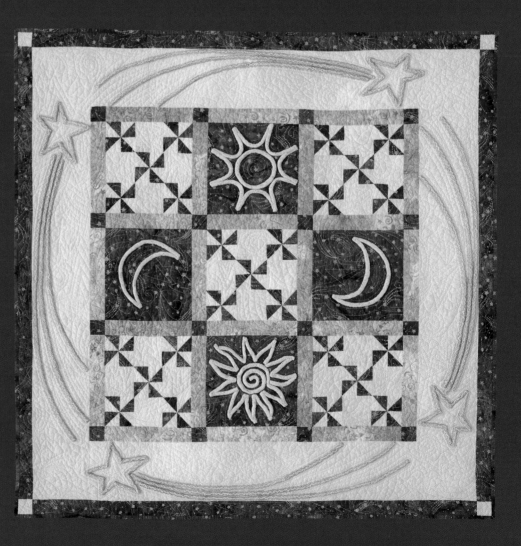

The bold chenille designs add just the punch this Shooting Stars quilt needs to bring the very simple piecing to life. Try using only one of the sun motifs and repeating it in the other sun squares for a simpler look. I machine quilted it using sun, moon, and shooting stars designs.

Cutting

{ **Tip:** Add a few inches to the borders so you can adjust them when your quilt center is finished!

Yellow: Cut 2 strips 6½″ × 33½″ and 2 strips 6½″ × 45½″ parallel to the selvage edge for borders.

From the remaining yellow, cut 20 squares 3½″ × 3½″ for the Windmill blocks.

Cut 4 squares 2″ × 2″ for outer border cornerstones.

Cut 10 strips 2½″ × 14″, then cut into 50 squares 2½″ × 2½″. Cut in half diagonally for 100 half-square triangles.

Blue: Cut 4 squares 9½″ × 9½″ for the alternate blocks.

Cut 6 strips 2″ wide, then cut 1 of these strips into 16 squares 2″ × 2″. Save the rest for the outer border.

Cut 6 strips 1½″ wide for single-fold binding.

Cut 4 strips 2½″ wide, then cut into 50 squares 2½″ × 2½″. Cut in half diagonally for 100 half-square triangles.

Aqua: Cut 6 strips 2″ wide, then cut into 24 pieces 2″ × 9½″ for sashing.

Construction

Windmill Blocks

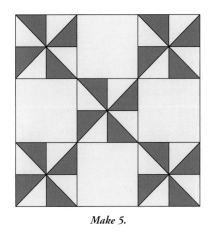

Make 5.

1. Using the blue and yellow triangles, make 100 half-square triangle units. Press seam allowances toward the blue. Trim to 2″ × 2″ square.

2. Assemble the half-square triangle units to make 25 pinwheels. Press seam allowances open to help the block lie flat.

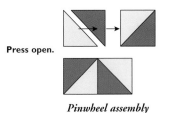

Press open.

Pinwheel assembly

Materials

- Yellow: 1½ yards for Windmill blocks, inner border, and cornerstones
- Blue: 1¼ yards for Windmill blocks, alternating blocks, outer border, sashing cornerstones, and binding
- Aqua: ½ yard for sashing
- Batting: 54″ × 54″
- Backing: 3 yards
- Fusible thread
- Water-soluble fabric marker

Chenille Color Stick Fabrics

- Yellows: 3 different fat eighths (9″ × 21″) for suns and moons
- Aquas: 3 different ¼-yard pieces for shooting stars

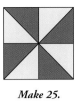

Make 25.

3. To assemble the Windmill block, alternate 3½″ yellow squares with pinwheel units as shown.

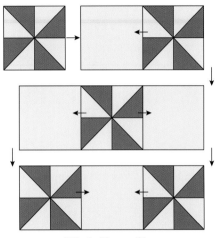

Windmill assembly

4. Press the seam allowances toward the alternate yellow squares. Stitch the rows together to make the Windmill block. Press the seam allowances to one side. Make 5 Windmill blocks.

Quilt Center Assembly

1. Stitch together 4 sashing and cornerstone units as shown. Press the seam allowances toward the sashing.

2. Stitch together the blocks and sashing strips as shown. Press the seam allowances toward the sashing.

3. Assemble the quilt center by stitching the rows together, alternating the sashing/cornerstone rows and the block/sashing rows. Press seam allowances to one side.

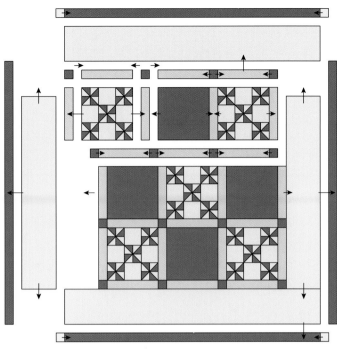

Shooting Stars assembly

Borders

Tip: Measure your quilt center and adjust the length of your border if necessary.

1. Stitch the 6½″ × 33½″ yellow borders to the sides of the quilt center, then add the 2 yellow 6½″ × 45½″ borders to the top and bottom. Press the seam allowances toward the borders.

2. For the blue outer border pieces, stitch the 5 remaining 2″ blue strips together diagonally end to end to make 1 long strip. Cut into 4 pieces 45½″, or the width of your quilt if it is different.

3. Stitch 2 outer border pieces to the sides of the quilt. Stitch and press 4 yellow 2″ cornerstone squares to the ends of the remaining 2 long outside border pieces. Stitch to the top and bottom of the quilt. Press toward the outside border.

4. Using the suns, star, moon (and moon reversed) patterns on pages 29–31, transfer the designs for the chenille color sticks to the quilt top. Refer to the photo to draw a star trail on each border.

5. Layer the backing, batting, and quilt top. Follow the directions on pages 10–15 for making and applying chenille color sticks.

6. Quilt and bind, then wash and dry to bring out the chenille!

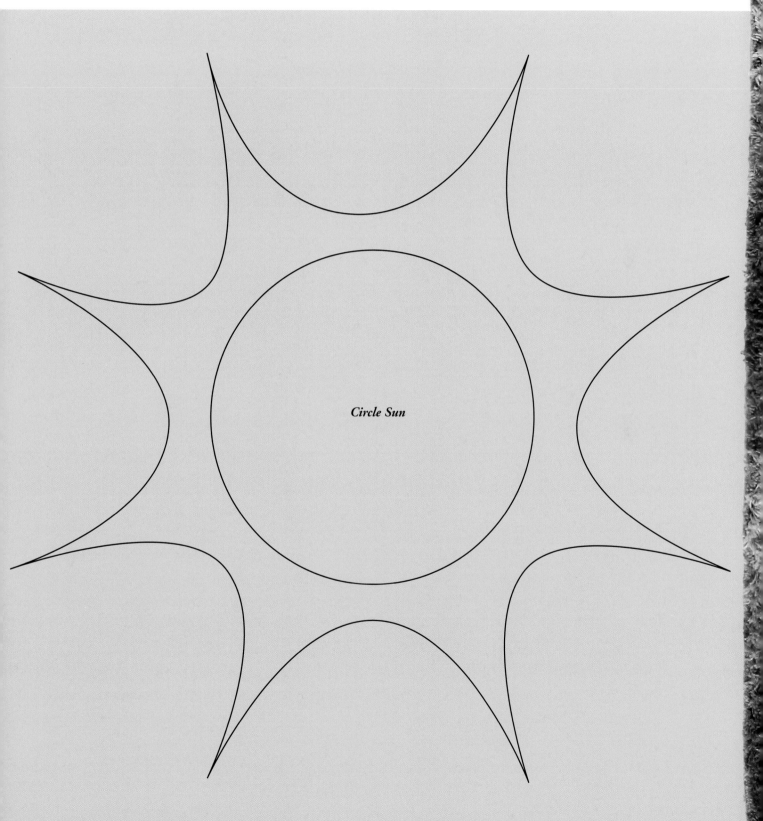

Circle Sun

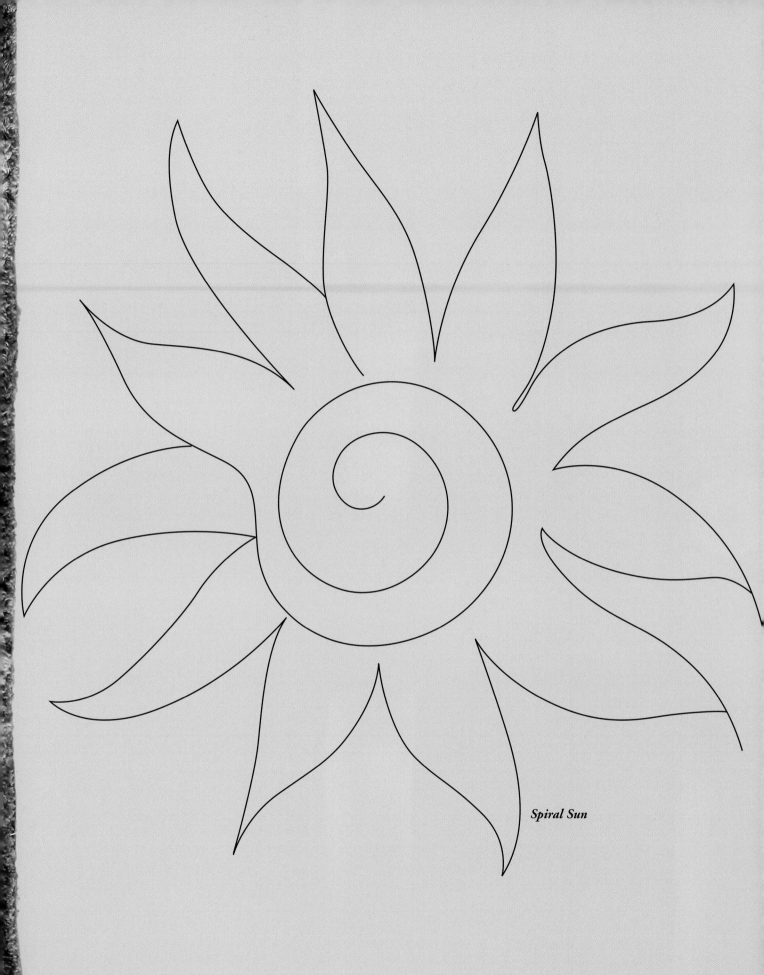

Spiral Sun

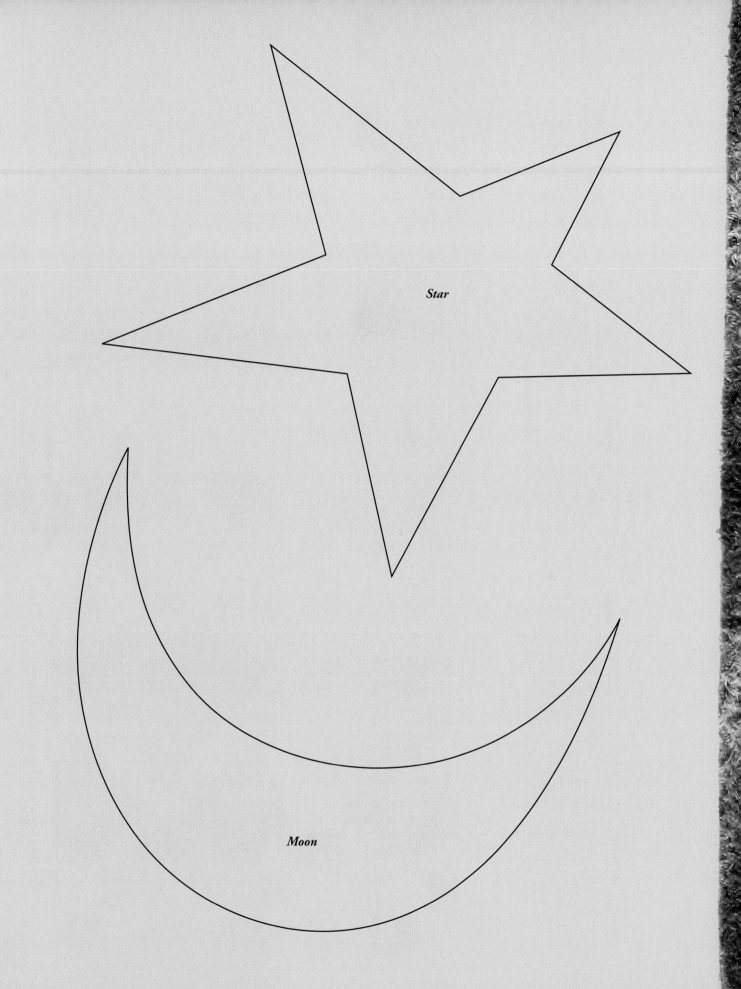

Star

Moon

Rosie Chain

Cheryl Malkowski, quilted by Denise Shelton, 2003

Finished Quilt Size: 72½" × 96½" Finished Block Size: 12"

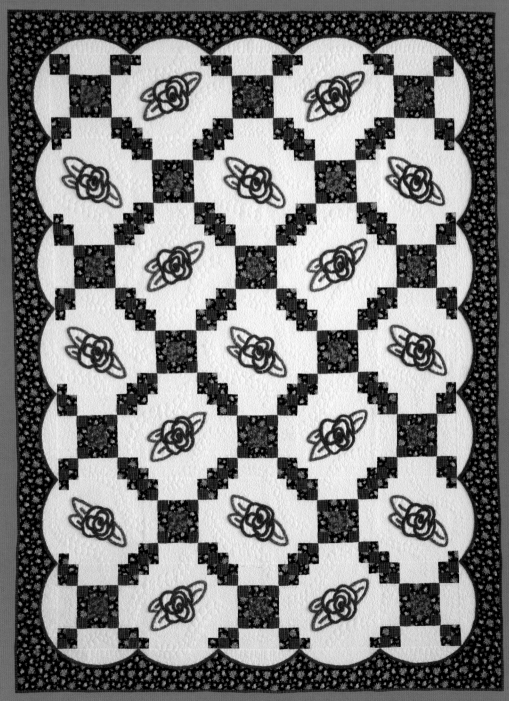

This fun, whimsical quilt features an easy scallop treatment using chenille color sticks. Just lay the scalloped "frame" on top of the quilt center, and baste and secure it when you stitch down the color sticks. For variety, try using another motif in the center. Change the roses to daisies, teddy bears, or whatever sparks your imagination for your featured chenille design. You'll have a completely different effect.

Cutting

Black floral: Cut 8 strips 2″ wide. Set aside for strip piecing four-patch units in the corners of the block.

Cut 2 strips 7″ × 86″ and 2 strips 7″ × 62″ parallel to the selvage edge for borders.

From the remaining black floral, cut 72 rectangles 2″ × 3½″.

Cut 68 squares 2″ × 2″.

Cut 4 squares 6½″ × 6½″.

Red: Cut 12 strips 2″ wide. Set aside 8 strips for strip piecing four-patch units in the corners of the block.

Cut the remaining 4 strips into 72 squares 2″ × 2″.

Cut 9 strips 1½″ wide for single-fold binding.

White: Cut 21 strips 3½″ wide. Set aside 9 strips for the inside border and cut the remaining 12 strips into 72 rectangles 3½″ × 6½″.

Cut 9 strips 2″ wide, then cut into 34 rectangles 2″ × 9½″.

Cut 6 strips 9½″ wide, then cut into 17 rectangles 9½″ × 12½″.

Green: Cut 2 strips 3½″ wide, then cut again to make 18 squares 3½″ × 3½″.

Construction

Chain Block

Make 18.

1. Stitch 1 black strip to 1 red strip along the long edge. Repeat with the remaining 7 pairs of strips. Press the seam allowances toward the black. After sewing the strips together, cut into 2″-wide units. You need 144 units 2″ × 3½″.

Stitch strips together; cut apart every 2″.

Materials

- Black floral: 3 yards for border and outer chain
- Red: 1¼ yards for inner chain and binding
- White: 4¼ yards for background
- Green: ⅓ yard for block center
- Batting: 80″ × 108″
- Backing: 5⅝ yards, or 2¼ yards of 108″ wide
- Fusible thread
- Water-soluble fabric marker
- Optional: Freezer paper for scallop template

Chenille Color Stick Fabrics

- Reds: 3 different ½-yard pieces for roses and scallop
- Greens: 3 different 9″ × 37″ rectangles for leaves

5. Using the Rose pattern and Rose pattern reversed on page 37, transfer the designs for the chenille color sticks to the quilt top.

{ **Tip:** You will also use color sticks along the scallop, matching the raw edge of the scallop with the edge of the color stick.

6. Layer the backing, batting, and quilt top. Follow the directions on pages 10–15 for making and applying chenille color sticks.

7. Quilt and bind the quilt, then wash and dry to bring out the chenille!

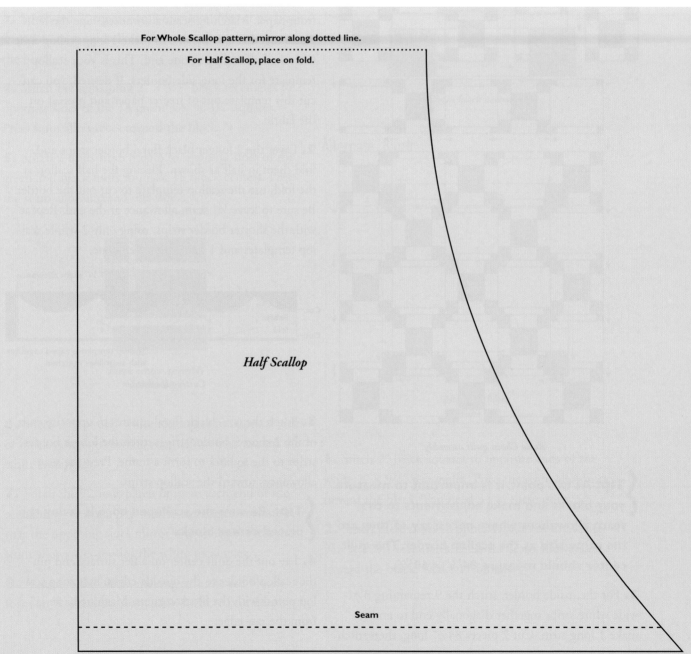

For Whole Scallop pattern, mirror along dotted line.

For Half Scallop, place on fold.

Half Scallop

Seam

Cutting line

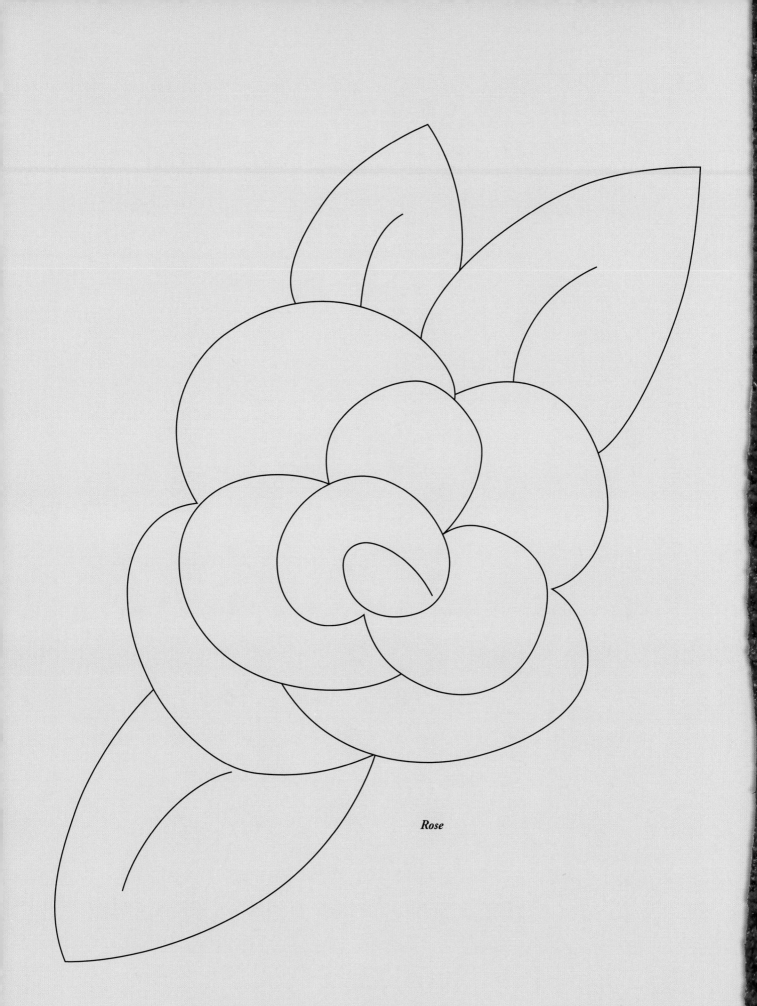

Rose

chapter 8

Antique Peonies

Cheryl Malkowski, 2003

Finished Quilt Size: 68½″ × 68½″ **Finished Block Size: 8″**

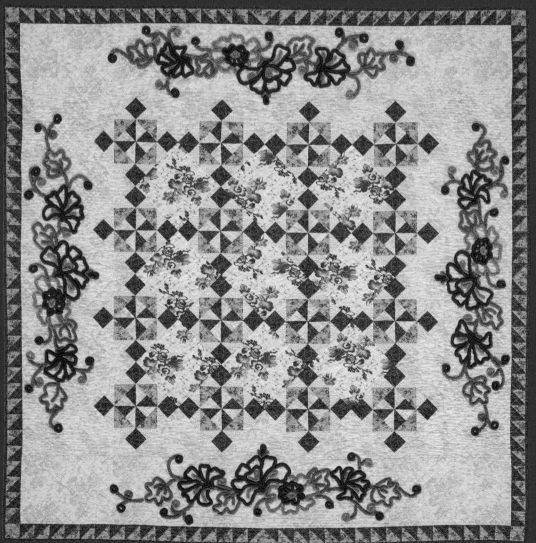

This project truly brings together the world of patchwork and the feel of old chenille bedspreads. The elegant floral design in the border softens the geometric patchwork.

Cutting

Green: Cut 8 strips 3″ wide, then cut into 96 squares 3″ × 3″. Cut in half diagonally to make 192 half-square triangles for blocks and Sawtooth border.

Cut 4 strips 2½″ wide, then cut into 64 squares 2½″ × 2½″.

Cut 8 strips 1½″ wide for single-fold binding.

Cream: Cut 3 strips 3″ wide, then cut into 32 squares 3″ × 3″. Cut in half diagonally to make 64 half-square triangles.

Cut 3 squares 14″ × 14″, then cut these squares twice diagonally to make 4 triangles from each square. You need 12 **side-setting** triangles.

Cut 2 squares 8¼″ × 8¼″, then cut in half diagonally to make 4 **corner-setting** triangles.

Cut 2 strips 9½″ × 46½″ parallel to the selvage edge for borders.

Cut 2 strips 9½″ × 64½″ parallel to the selvage edge for borders.

Pink: Cut 3 strips 5¼″ wide, then cut 16 squares 5¼″ × 5¼″. Cut these twice diagonally to make 64 triangles for the Flying Geese units.

From the remnant of the third strip, cut 4 squares 2½″ × 2½″ for the outside border cornerstones.

Cut 5 strips 3″ wide, then cut into 64 squares 3″ × 3″. Cut in half diagonally to make 128 half-square triangles.

Cream print: Cut 5 strips 3″ wide, then cut into 64 squares 3″ × 3″. Cut in half diagonally to make 128 half-square triangles.

Large floral: Cut 3 strips 8½″ wide, then cut into 9 squares 8½″ × 8½″ for alternate blocks.

Materials

- Green: 1½ yards for pinwheel units, outer squares in Pinwheel Mosaic block, Sawtooth border, and binding
- Cream: 3 yards for pinwheel units in Pinwheel Mosaic block, setting triangles, and wide borders
- Pink: 1 yard for Flying Geese units and Sawtooth border
- Cream print: ½ yard for Flying Geese triangles
- Large floral: ⅞ yard for alternating block, more if you want to fussy cut
- Batting: 72″ × 72″
- Backing: 4 yards
- Fusible thread
- Water-soluble fabric marker

Chenille Color Stick Fabrics

- Burgundies: 3 different ⅜-yard pieces for flowers and buds
- Pinks: 3 different ¼-yard pieces for flowers and buds
- Greens: 3 different ¼-yard pieces for leaves

Construction

Pinwheel Mosaic block

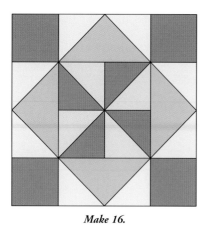

Make 16.

1. Using the green and cream triangles cut from the 3″ squares, make 64 half-square triangle units. Press the seam allowances toward the green fabric. Trim to 2½″ × 2½″ square.

2. Assemble the half-square triangle units to make 16 pinwheel units. Press the seam allowance open to help the block center lie flat.

Press open. ———

Make 16.

3. Stitch 64 cream print half-square triangles to the pink Flying Geese triangles along the bias edge as shown. Press toward the cream print.

4. Stitch the remaining 64 cream print half-square triangles to the opposite side of the pink Flying Geese triangles. Press the seam allowances toward the cream print and trim to 2½″ × 4½″, making sure there is ¼″ seam allowance at the point of the goose.

Match triangle points at lower corner.

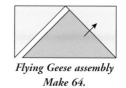

Flying Geese assembly
Make 64.

5. Stitch the Flying Geese units to 2 opposite sides of the pinwheel units. The point of the Flying Goose should face away from the pinwheel. Press the seam allowances toward the pinwheel units.

6. Stitch the green 2½″ squares to the narrow ends of the remaining 32 Flying Geese units. Press the seam allowances toward the green.

7. Assemble the block by stitching these units to both sides of the pinwheel units. Press the seam allowances to one side.

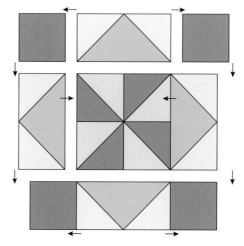

Pinwheel Mosaic block assembly

Quilt Assembly

1. Assemble the quilt center in diagonal rows, alternating the Pinwheel Mosaic blocks and the alternate blocks. Add side-setting and corner-setting triangles as shown. Press toward the alternate blocks and setting triangles. Sew the rows together. Press rows in one direction.

2. Trim the quilt center to 46½″ × 46½″, centering the blocks.

> **Tip:** The setting triangles are sized generously so you can "float" the center blocks without losing any corners. This also allows you to cut the quilt center to match the borders precisely, which is important with the pieced outer border.

3. Stitch 2 cream 9½″ × 46½″ border strips to the sides of the quilt center. Stitch 2 cream 9½″ × 64½″ border strips to the top and bottom of the quilt center. Press toward the border.

Sawtooth Border

1. Using the remaining green and pink triangles, make 128 half-square triangle units. Press the seam allowances toward the green. Trim to 2½″ × 2½″ square.

2. For the outer Sawtooth borders, stitch 4 sets of 16 half-square triangle units together side to side with green on the right and 4 sets of 16 half-square triangle units together side to side with green on the left as shown. From these, make 4 long outside borders with 32 squares as shown.

Sawtooth border assembly

> **Tip:** Measure the length of your Sawtooth borders and be sure they all measure 64½″ to ensure that your quilt will lie flat. Adjust seam allowances if necessary.

3. Stitch 2 Sawtooth borders to the sides of the quilt. Press toward the wide border.

> **Tip:** Stitch carefully to preserve the points of the Sawtooth border!

4. Stitch a 2½″ × 2½″ pink square to each end of two Sawtooth border units. Stitch these to the quilt to complete the top. Press toward the wide border.

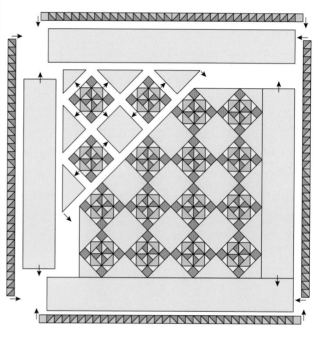

Antique Peonies quilt assembly

5. Using the Peony Border pattern on side 2 of the pullout, transfer the design for the chenille color sticks to the quilt top.

6. Layer the backing, batting, and quilt top. Follow the directions on pages 10–15 for making and applying chenille color sticks. Quilt and bind, then wash and dry to bring out the chenille!

> **Tip:** The chenille design for the border of this quilt has lots of little circles to apply. To make these easier, cut 2¾″ segments of the chenille color stick and wrap them around your finger, overlapping the ends about ¼″ before setting them on the quilt. See page 13 for more information on applying circles.

Color Stick Measurement Guide

My hope is that the designs in the gallery inspire you to get started on something simple but creative for yourself. Here is a list of the approximate yield of usable color sticks when 3 squares of fabric are cut in half diagonally and the ends of the color sticks are blunt cut. Have fun!

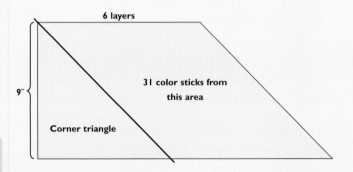

Color Stick Yield

3″ square yields 8″	7″ square yields 61″
4″ square yields 17″	8″ square yields 80″
5″ square yields 29″	9″ square yields 101″
6″ square yields 44″	

Using three ¼-yard pieces (9″ × width of fabric), stacked and cut in the center on the bias (see page 10), the yield of color sticks is 31 sticks that are 12″ long, which equals 372″, plus 101″ from the corner triangle, for a total of 473″.

In the same way, fat eighths (9″ × 21″) will yield 12 sticks that are 12″ long, which equals 144″, plus 101″ from the corner triangle, for a total of 245″.

Starting with a 9″ square, every inch you add in width to the rectangle—for example, 9″ × 10″ instead of 9″ × 9″—will add one more 12″-long color stick to your total. So, since the yield from the 9″ square is 101″, the yield from a 9″ × 10″ rectangle is 113″, the yield from a 9″ × 11″ rectangle is 125″, and so on.

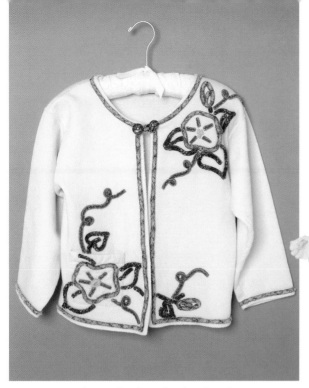

Morning Glory Bed Jacket, Cheryl Malkowski, 2003

Gallery

Decorated Tote, Cheryl Malkowski, 2003

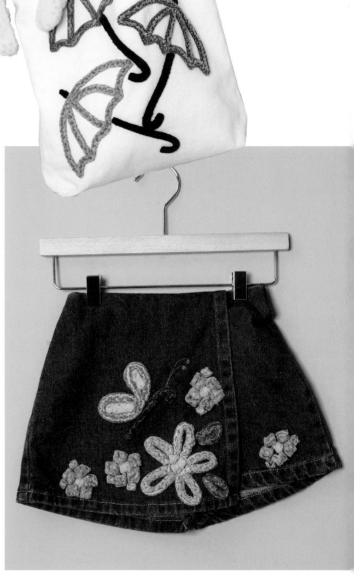

The chenille color stick technique offers a fast, easy way to personalize any washable, ready-made item. All you need are a few color sticks and a few moments to apply them to the garment. Just draw your design on the item with a water-soluble marker. Press the chenille color sticks into place to fuse them, stitch down, and wash!

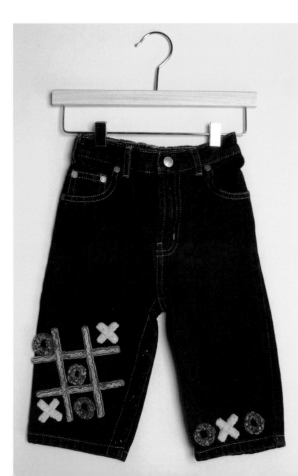

Toddler's Skort, Cheryl Malkowski, 2003

Toddler's Pants, Cheryl Malkowski, 2003

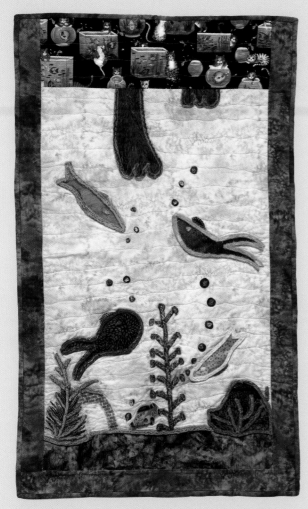

John's Aquarium, 25″ × 41″, Rose Smith, 2003, inspired by her grandson Ryan's artwork

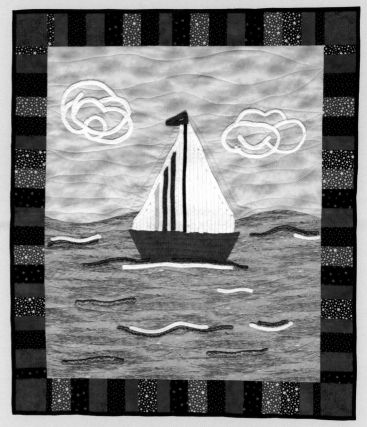

Sailing, Sailing, 54″ × 45″, Gloria Beucler, 2003

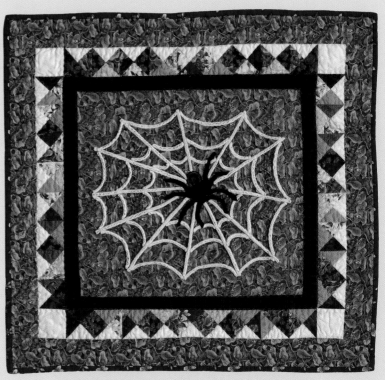

Gerty the Garden Spider, 28″ × 30″, Shirley Pyle, 2003

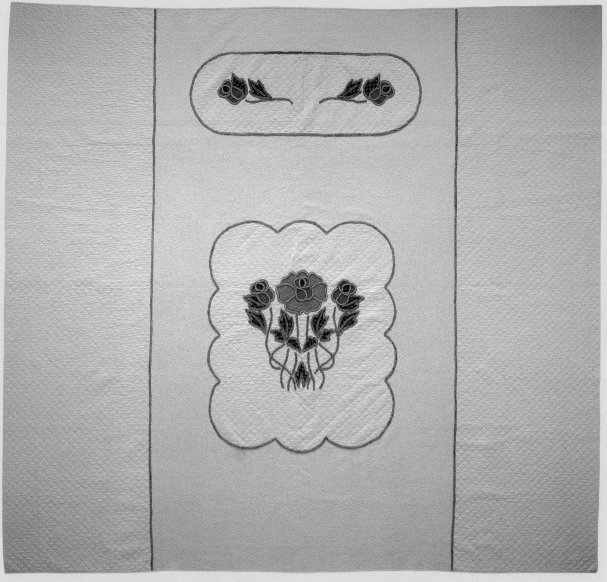

Roses Bedspread, 112″ × 102″, Linda Dukes, 2003

Linda designed this quilt for her queen-size bed. In April 2003 the quilt took a blue ribbon in a juried show; and the second time it was shown, in September 2003, it won second place with a Viewers' Choice Award. She quilted it on her longarm quilting machine.

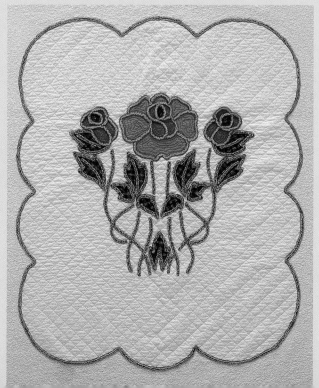

Detail of Roses Bedspread, Linda Dukes, 2003

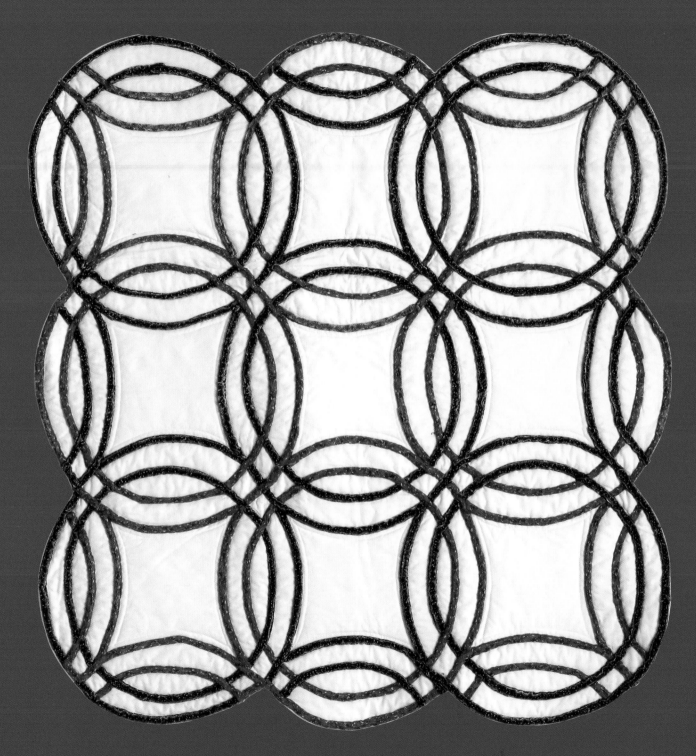

Chenille Wedding Ring, 38" × 38", Gloria Beucler, 2003

Resource List

Fusible thread is vital to this technique but is sometimes hard to find. If it's not stocked at your local quilt shop, it can be ordered from these manufacturers:

YLI Corporation
161 West Main Street
Rock Hill, SC 29730
www.ylicorp.com
800-296-8139

Prym-Dritz Corporation
www.dritz.com
800-845-4948

The regular and fusible varieties of Hobbs Heirloom Premium Cotton Blend Batting are excellent choices for use with chenille color sticks.

Hobbs Bonded Fibers
200 S. Commerce Drive
Waco, TX 76710
http://hobbsbondedfibers.com
800-433-3357

About the Author

Photo courtesy of Terry Day

Cheryl started sewing doll clothes in fifth grade with scraps from the sewing kit at her best friend's house. In high school, she challenged herself to make original clothing that looked as good as what could be found in the stores. On the road that led to the discovery of quilting in 1993, she expressed herself in floral design, music, and garment design. When it became obvious that quilting was what made her happy, she laid aside her work to focus full time on quilting. She now spends her time designing and sewing quilts, writing patterns, and teaching, and she can't decide which part she likes best.

Cheryl enjoys every genre of quilting, but her favorite quilts feature flowers. Her work in chenille embraces what she calls "third-grade art"—nothing too complex, but fun. She still uses doodles she originated during elementary school as motifs in her machine quilting and as inspiration for fantasy flowers.

When she's not in her studio, Cheryl enjoys listening to or playing good music, gardening, and traveling. She loves God, her family (including the dog), and good friends. She lives in a small town in southern Oregon, where the biggest thrill is visiting the fish ladder.

For information about workshops, lectures, and ways of contacting Cheryl, visit her website at www.cherylmalkowski.com

OTHER FINE BOOKS FROM C&T PUBLISHING

All About Machine Arts—Decorative Techniques from A to Z, From Sew News Creative Machine Embroidery & C&T Publishing

All About Quilting from A to Z, From the Editors and Contributors of Quilter's Newsletter Magazine and Quiltmaker Magazine

Art Glass Quilts: New Subtractive Appliqué Technique, Julie Hirota

Art of Fabric Books, The: Innovative Ways to Use Fabric in Scrapbooks, Altered Books & More, Jan Smiley

Beading Basics: 30 Embellishing Techniques for Quilters, Mary Stori

Benni Harper's Quilt Album: A Scrapbook of Quilt Projects, Photos & Never-Before-Told Stories, Earlene Fowler & Margrit Hall

Borders, Bindings & Edges: The Art of Finishing Your Quilt, Sally Collins

Celebrate Great Quilts! circa 1820—1940: The International Quilt Festival Collection, Karey Patterson Bresenhan & Nancy O'Bryant

Circle Play: Simple Designs for Fabulous Fabrics, Reynola Pakusich

Classic Four-Block Appliqué Quilts: A Back-to-Basics Approach, Gwen Marston

Country Quilts for Friends: 18 Charming Projects for All Seasons, Margaret Peters & Anne Sutton

Curves So Simple: No Appliqué, Pinless Piecing, Dale Fleming

Diamond Quilts & Beyond: From the Basics to Dazzling Designs, Jan Krentz

Fabric Journey, A: An Inside Look at the Quilts of Ruth B. McDowell, Ruth B. McDowell

Fast, Fun & Easy Fabric Bags: 10 Projects to Suit Your Style, Pam Archer

Fast, Fun & Easy Fabric Bowls: 5 Reversible Shapes to Use & Display, Linda Johansen

Fast, Fun & Easy Fabric Boxes, Linda Johansen

Finish It with Alex Anderson: 6 Quilt Projects •Choose the Perfect Border •Options for Edges, Alex Anderson

From the Cover: 15 Memorable Projects for Quilt Lovers, Mary Leman Austin & Quilter's Newsletter Magazine Editors & Contributors

Fusing Fun! Fast, Fearless Art Quilts, Laura Wasilowski

Gathered Garden, A: 3-Dimensional Fabric Flowers •15 Projects—Quilts & More •Mix & Match Bouquets, Carol Armstrong

Heirloom Machine Quilting, 4th Edition: Comprehensive Guide to Hand-Quilting Effects Using Your Sewing Machine, Harriet Hargrave

Laurel Burch Christmas, A: Color the Season Beautiful with 25 Quilts & Crafts, Laurel Burch

Machine Appliqué Made Easy: A Beginner's Guide to Techniques, Stitches & Decorative Projects, Jean Wells

Machine Embroidety Makes the Quilt: 6 Creative Projects •CD with 26 Designs •Unleash Your Embroidery Machine's Potential, Patty Albin

Perfect Blocks in Minutes—The Make It Simpler Way: Revolutionary Technique •One-Piece Paper Foundations to Fold & Sew •60 Traditional Blocks, Anita Grossman Solomon

Phenomenal Fat Quarter Quilts: New Projects with Tips to Inspire & Enhance Your Quiltmaking, M'Liss Rae Hawley

Photo Fun: Print Your Own Fabric for Quilts & Crafts, The Hewlett-Packard Company, Edited by Cyndy Lyle Rymer

Pineapple Stars: Sparkling Quilts, Perfectly Pieced, Sharon Rexroad

Quilt & Embellish in One Step!, Linda Potter

Return to Elm Creek: More Quilt Projects Inspired by the Elm Creek Quilts Novels, Jennifer Chiaverini

Show Me How to Create Quilting Designs: 70 Ready-to-Use Designs •6 Projects •Fun, No-Mark Approach, Kathy Sandbach

Simple Fabric Folding for Halloween: 14 Fun Quilts & Other Projects, Liz Aneloski

Small Quilts with Vintage Charm: 8 Projects to Decorate Your Home, Jo Morton

Stars by Magic: New Super-Easy Technique! Diamond-Free® Stars from Squares & Rectangles! Perfect Points and No Y-Seams!, Nancy Johnson-Srebro

Winning Stitches: Hand Quilting Secrets •50 Fabulous Designs •Quilts to Make, Elsie Campbell

Winter Wonders: 15 Quilts & Projects to Celebrate the Season, Edited by Jennifer Rounds & Catherine Comyns

Wonderfully Whimsical Quilts: 10 Playful Projects to Make You Smile, Carol Burniston

FOR MORE INFORMATION, ASK FOR A FREE CATALOG:

C&T Publishing, Inc.
P.O. Box 1456
Lafayette, CA 94549
(800) 284-1114
Email: ctinfo@ctpub.com
Website: www.ctpub.com

FOR QUILTING SUPPLIES:

Cotton Patch Mail Order
3405 Hall Lane, Dept.CTB
Lafayette, CA 94549
(800) 835-4418
(925) 283-7883
Email: quiltusa@yahoo.com
Website: www.quiltusa.com

NOTE: Fabrics used in the quilts shown may not be currently available beause fabric manufacturers keep most fabrics in print for only a short time.